A Keepsake

MARYLAND'S EASTERN SHORE

Antelo Devereux Jr.

SCHIFFER PUBLISHING

4880 Lower Valley Road · Atglen, PA 19310

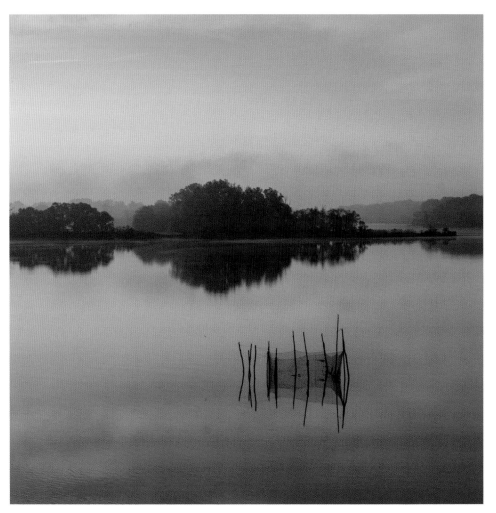

Bohemia River

INTRODUCTION

There is something peaceful and serene about the Eastern Shore of the Chesapeake Bay. Its low-lying, flat farmland with estuarial marsh edges is penetrated and drained by numerous river systems. First occupied by Native Americans and then colonized by the English led by Captain John Smith of the Virginia Company, this portion of Maryland has been fertile ground for farming and fishing for generations.

The region lies south of the busy I-95 metropolitan corridor and has about it a slightly genteel southern flavor. While farming remains strong, the hunting and fishing economies are suffering—once-abundant wildfowl, fish, crab, and oyster takes have slowly diminished because of overfishing combined with the bay's pollution with silt and fertilizer runoff from the many watersheds that feed it. Additionally, sea level rise threatens the very existence of fishing villages along the marshes and places, such as Smith Island, which are barely above sea level.

Over time the region has become a destination for vacationers and boaters from along the metropolitan corridor. No doubt they are attracted to, enjoy, and value the natural resource that the Eastern Shore represents. Today, organizations such as the Chesapeake Bay Foundation and Riverkeepers play an active role in reversing the destructive trends that have impaired the viability of the bay and the local economies so dependent on it.

I hope my photographs will entertain viewers and, more importantly, remind them of the valuable and irreplaceable asset the Chesapeake Bay and its environs represents.

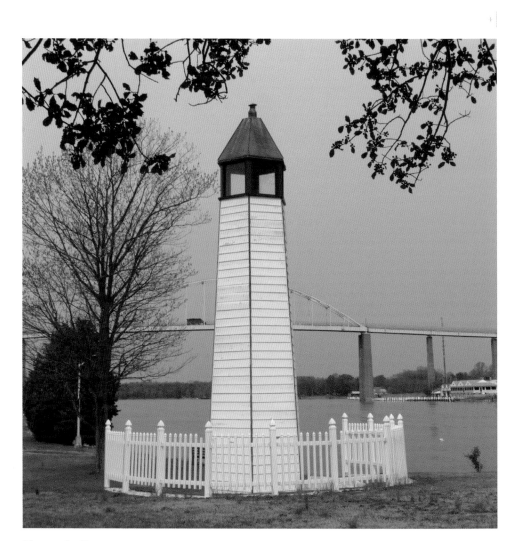

Chesapeake City

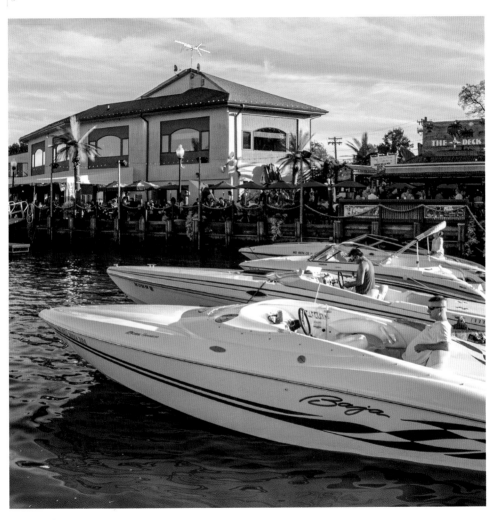

Chesapeake City

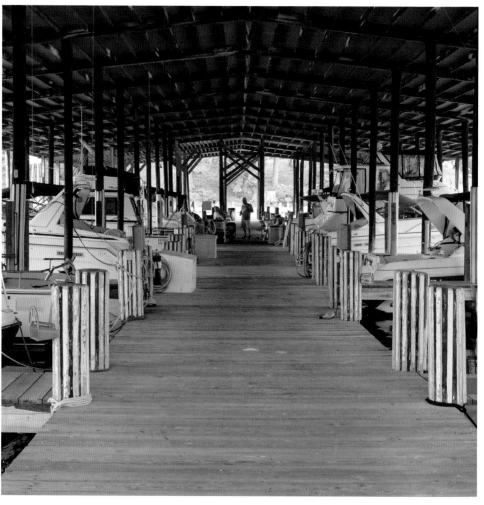

Tolchester

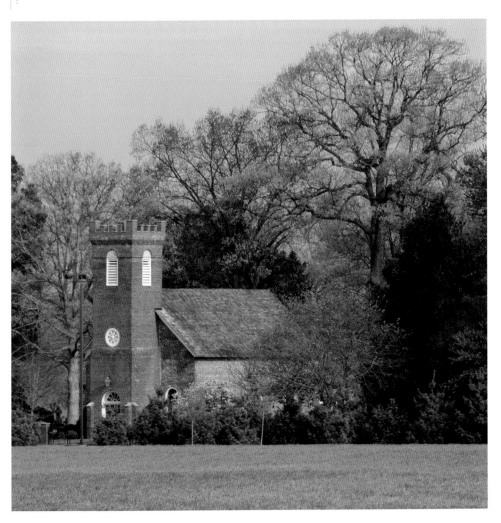

Kennedyville

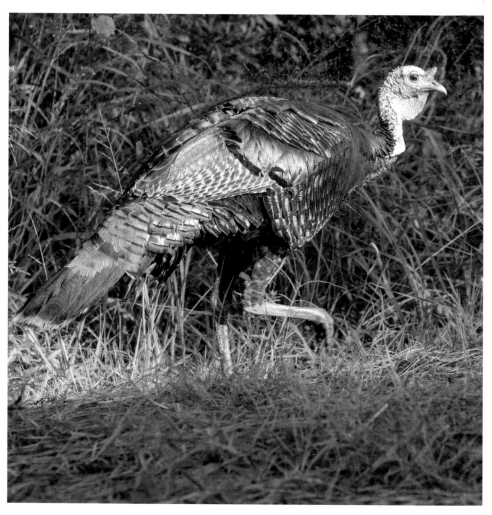

Wild turkey

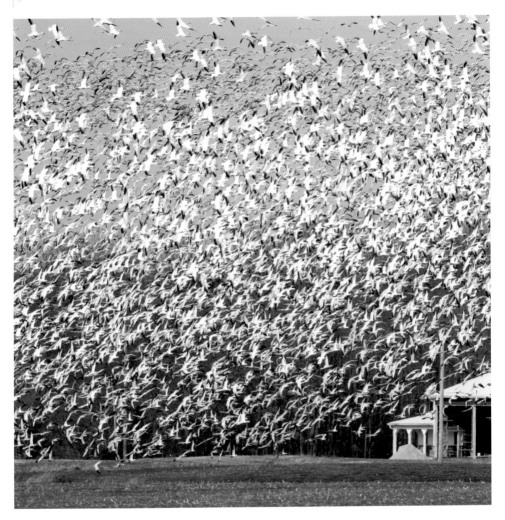

Snow geese

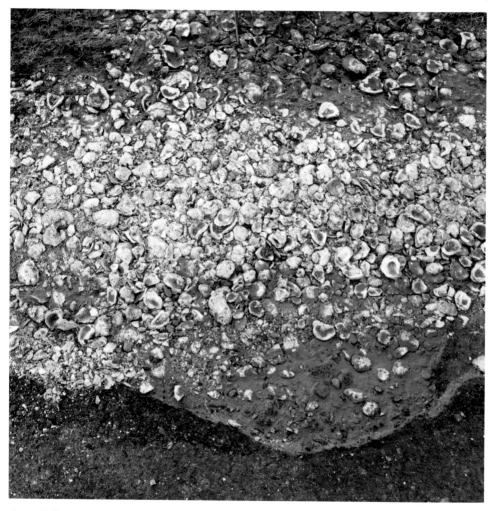

Oystershells

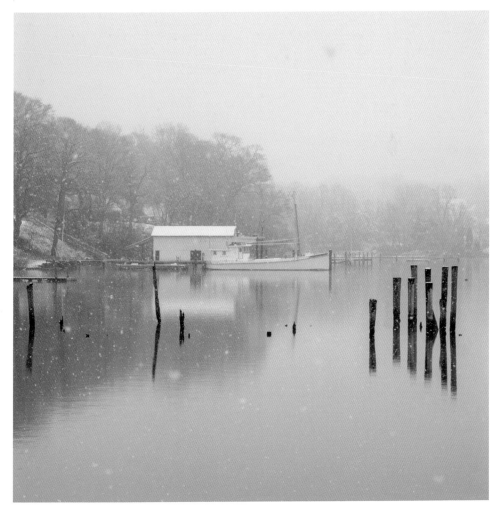

Georgetown, Sassafras River

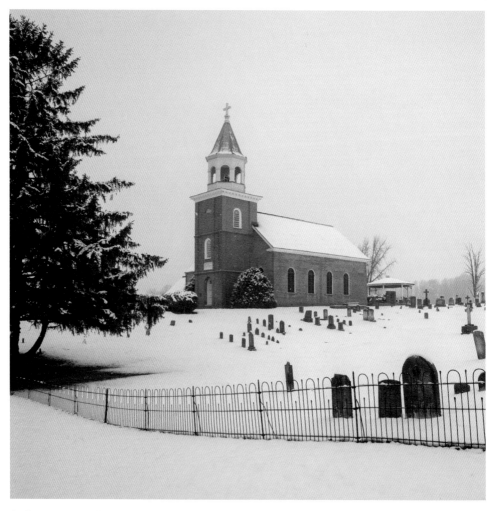

St. Francis Xavier Church, Warwick

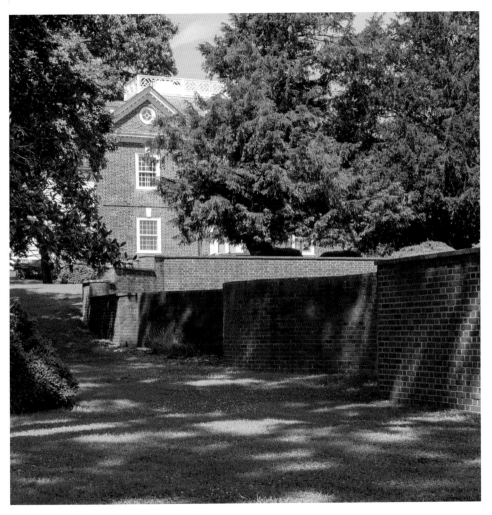

Mount Harmon

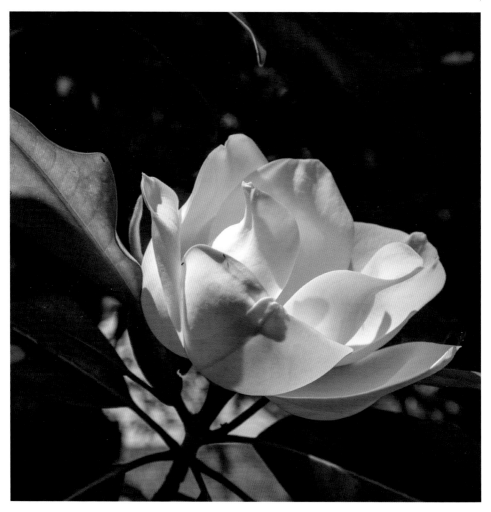

Magnolia flower

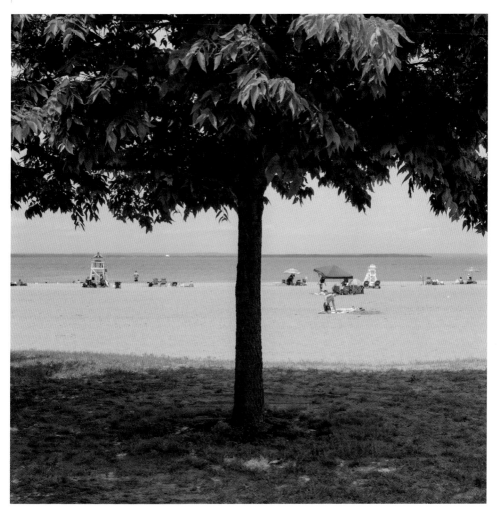

Betterton

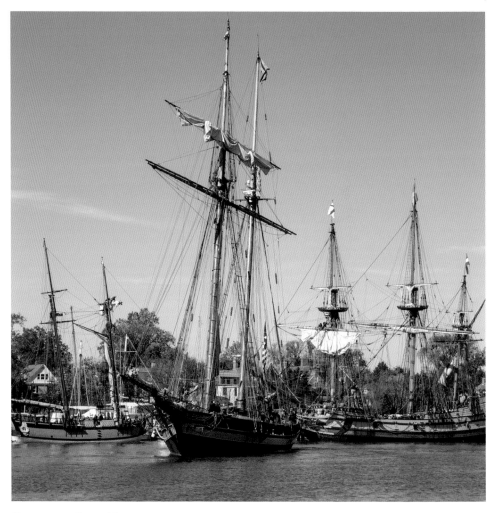

Chestertown, Chester River

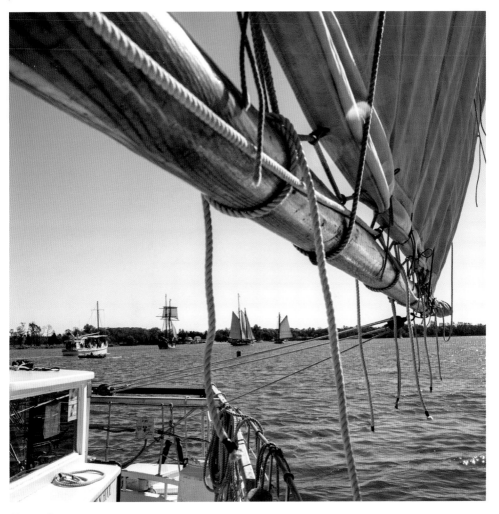

Chester River

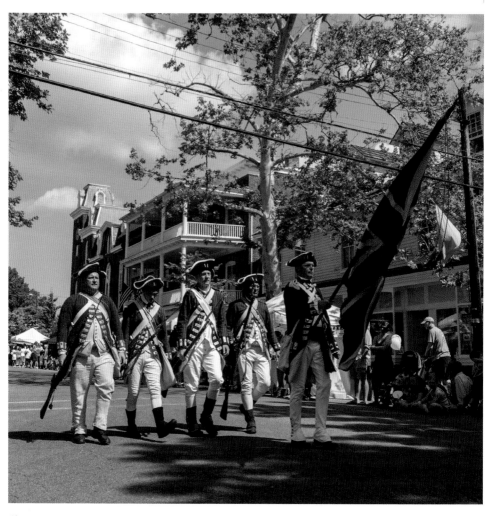

Chestertown

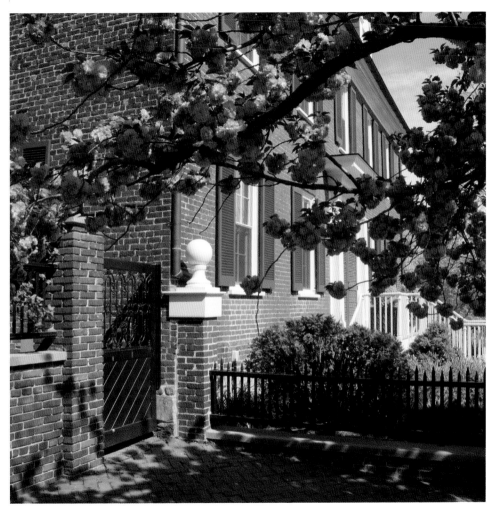

Chestertown

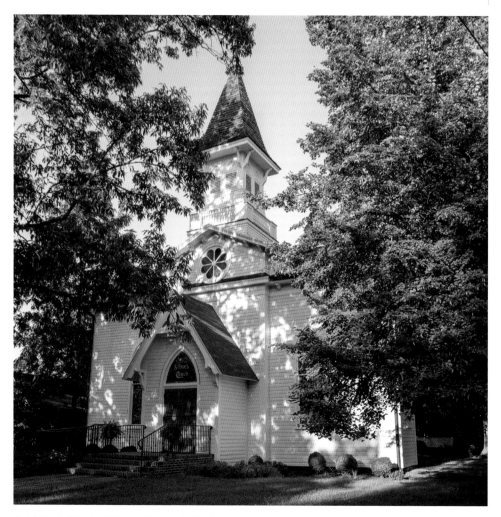

Saint Paul's Pilgrim Holiness Church, Oxford

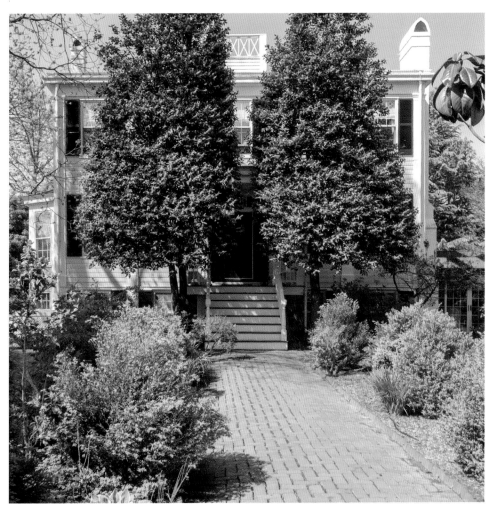

Oxford

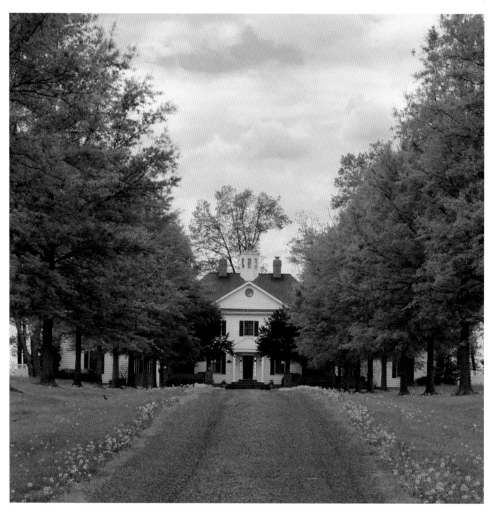

Kent Island

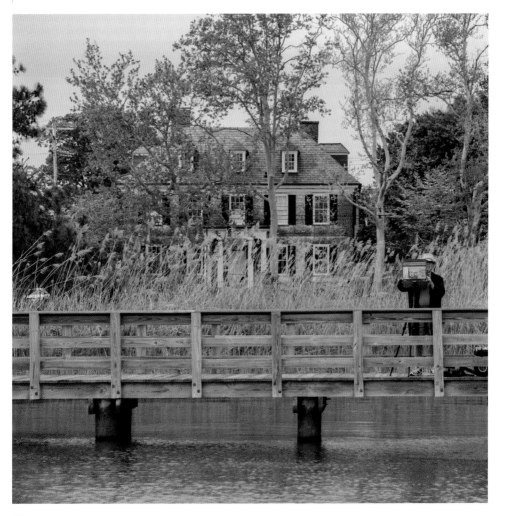

Chestertown

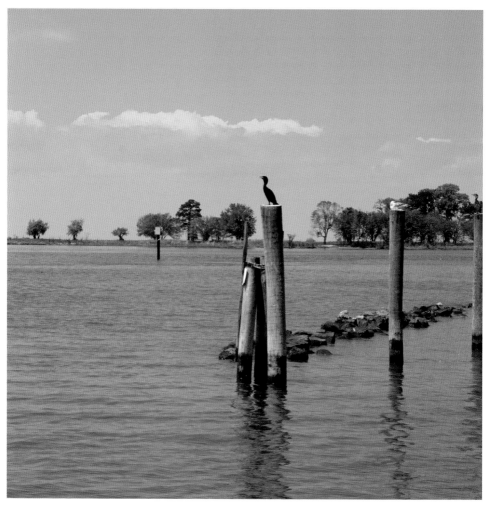

Kent Island Narrows

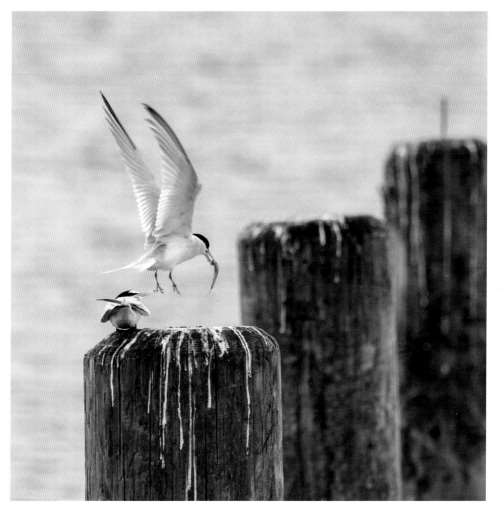

Eastern Neck Island

Kent Island Narrows

Stevensville

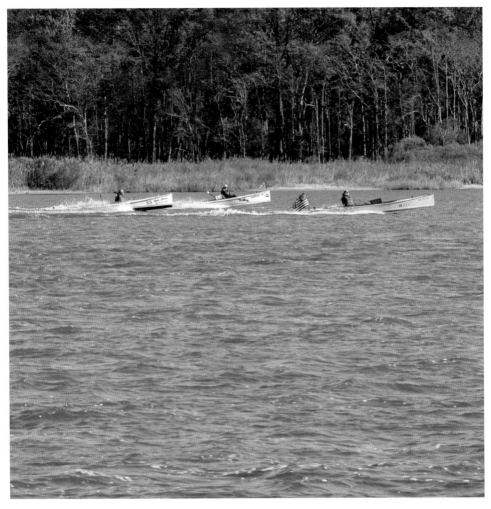

Smith Island crab skiffs, Chester River

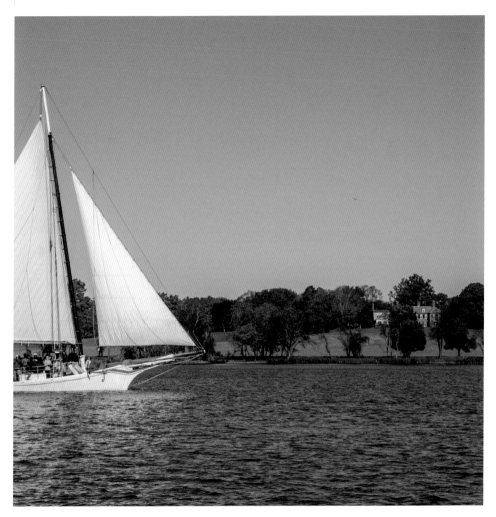

Skipjack, Chester River

Washington College, Chestertown

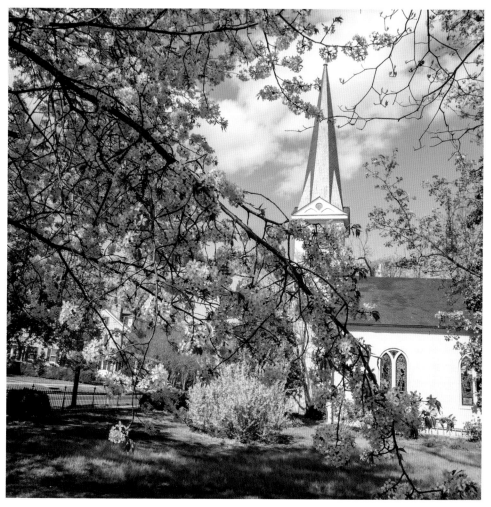

Centreville

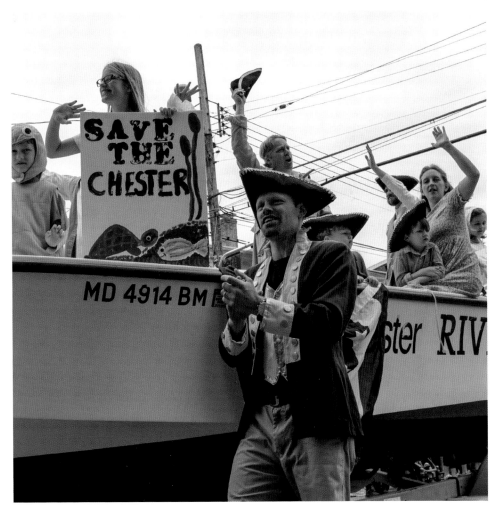

Chestertown

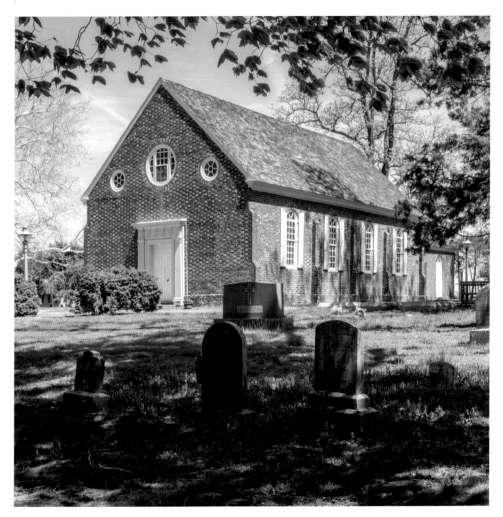

Old Wye Episcopal Church, Wye Mills

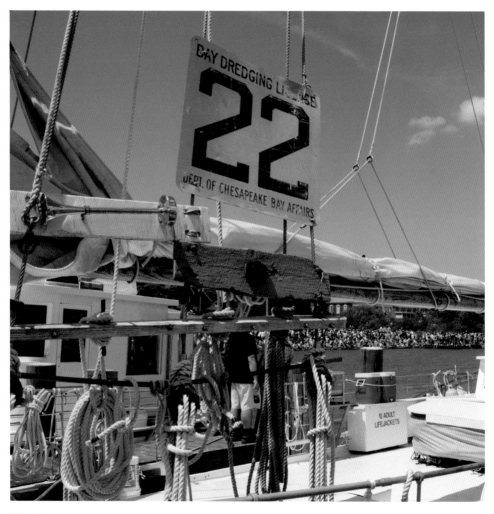

BAY DREDGING LICENSE

22

DEPT. OF CHESAPEAKE BAY AFFAIRS

10 ADULT
LIFEJACKETS

Chestertown

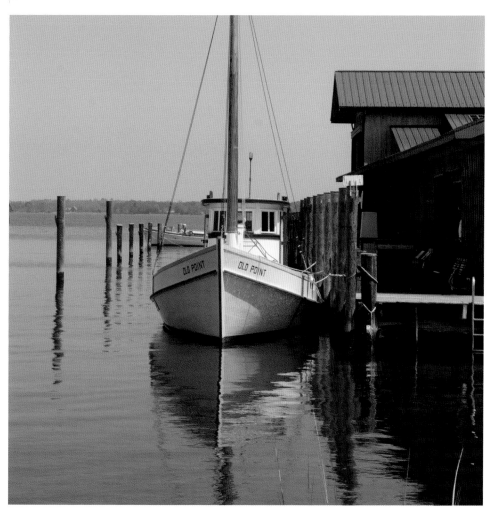

Chesapeake Bay Maritime Museum, St. Michaels, Miles River

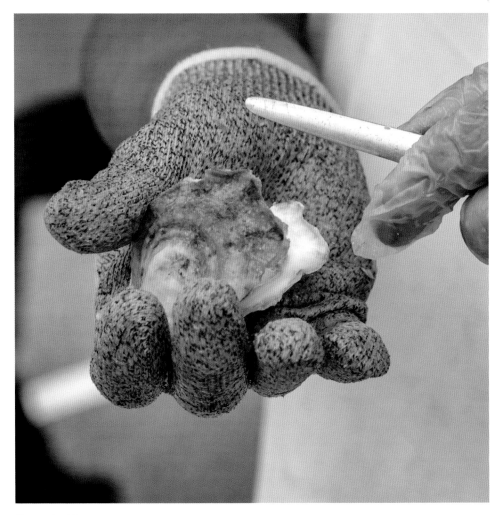

Oyster shucking

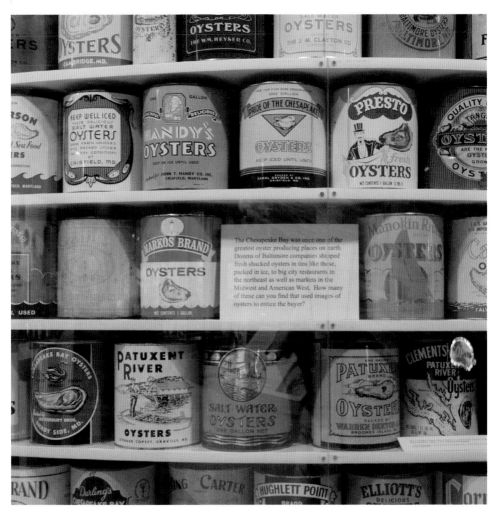

The Chesapeake Bay was once one of the greatest oyster producing places on earth. Dozens of Baltimore companies shipped fresh shucked oysters in tins like these, packed in ice, to big city restaurants in the northeast as well as markets in the Midwest and American West. How many of these can you find that used images of oysters to entice the buyer?

Chesapeake Bay Maritime Museum, St. Michaels, Miles River

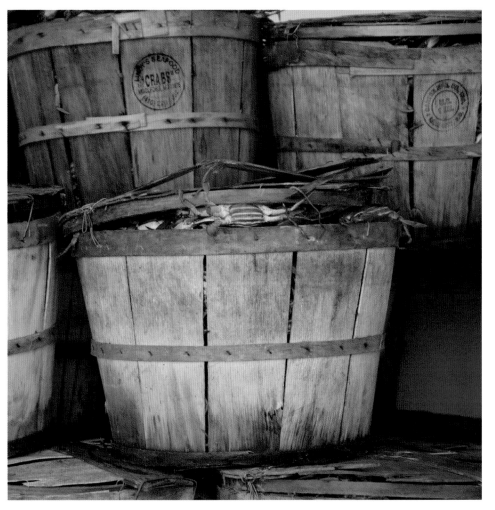

Tilghman Island

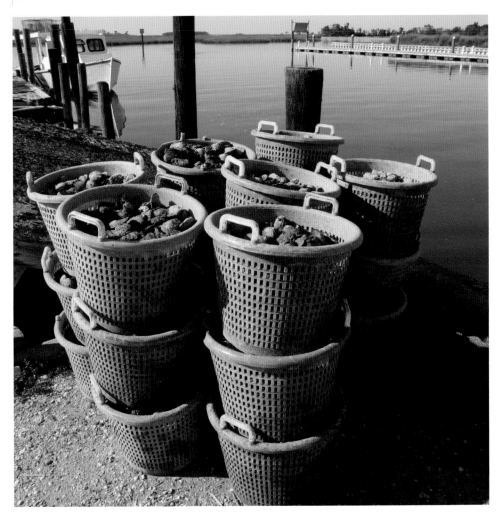

Tilghman Island

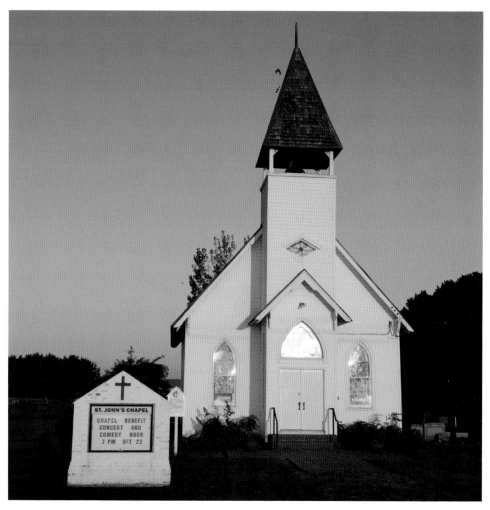

St. John's Chapel, Tilghman Island

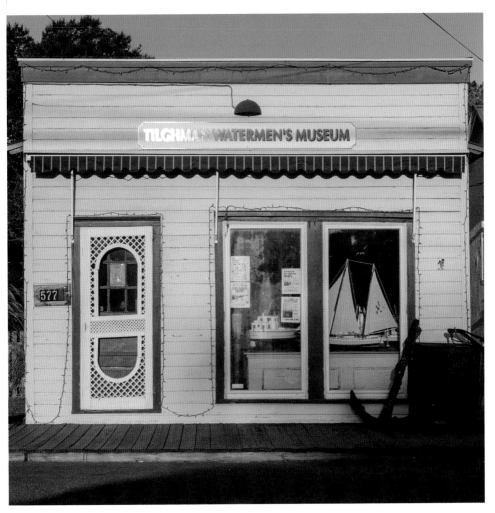

Tilghman Island

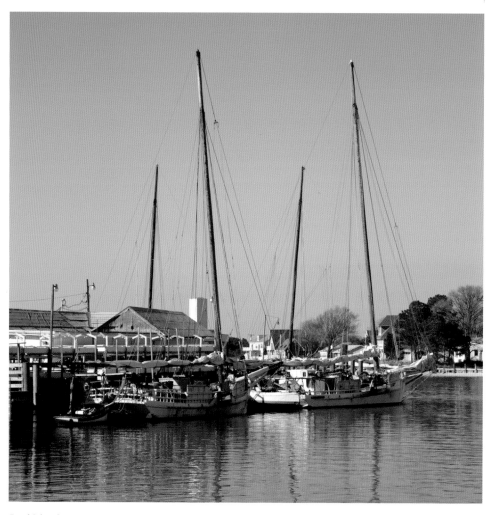

Deal Island

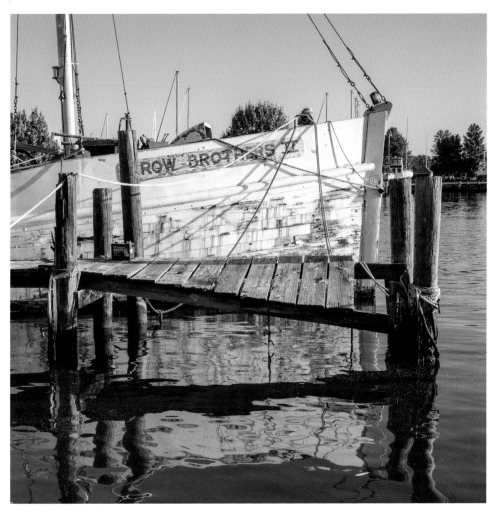

Tilghman Island

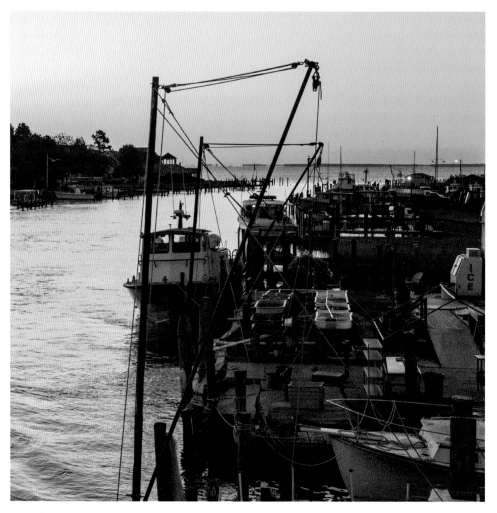

Knapp's Narrows

Wye Mills

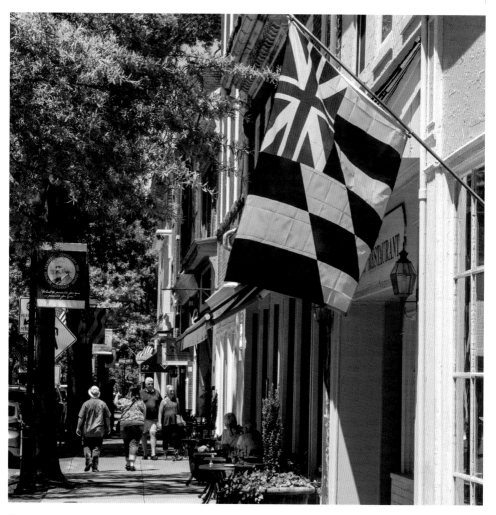

Easton

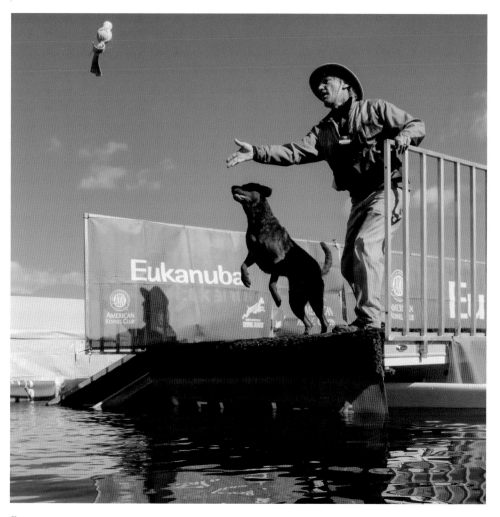

Easton

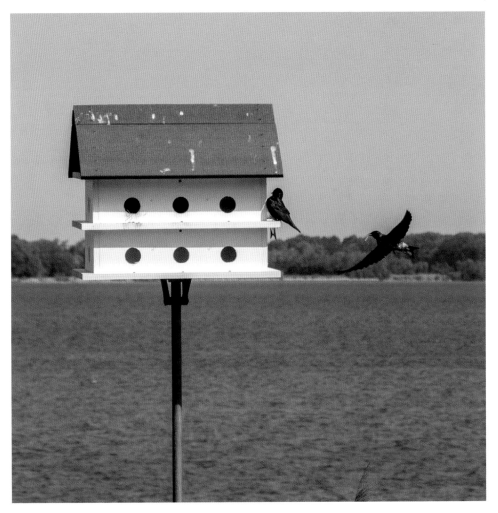

Oxford, Tred Avon River

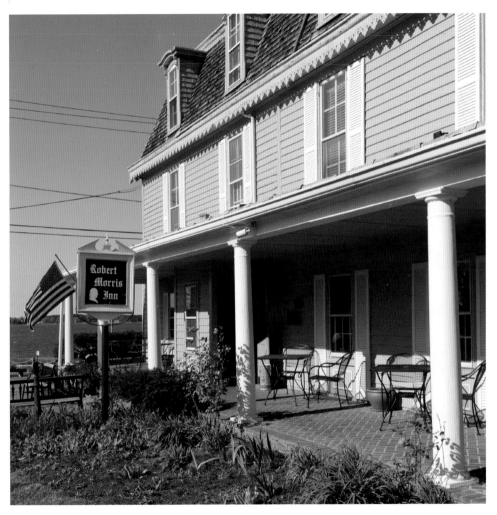

Oxford, Tred Avon River

St. Michaels, Miles River

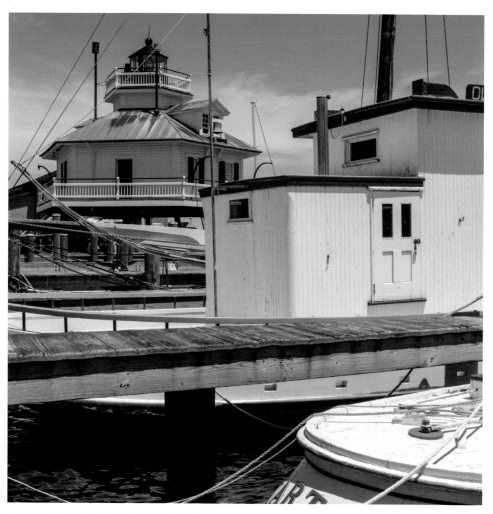

Chesapeake Bay Maritime Museum, St. Michaels, Miles River

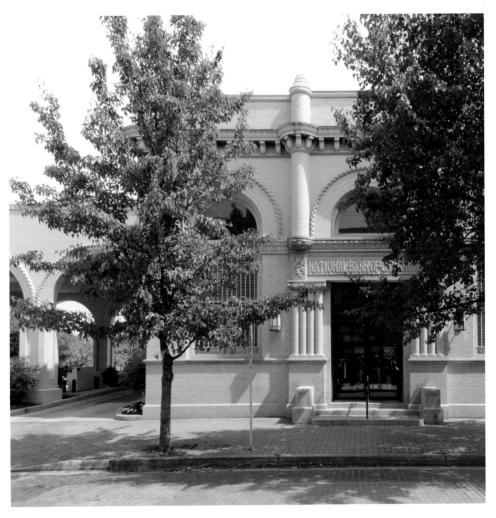

Cambridge

Cambridge

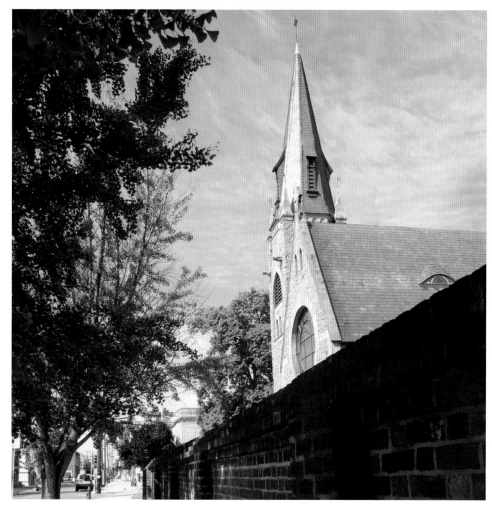

Christ Episcopal Church, Cambridge

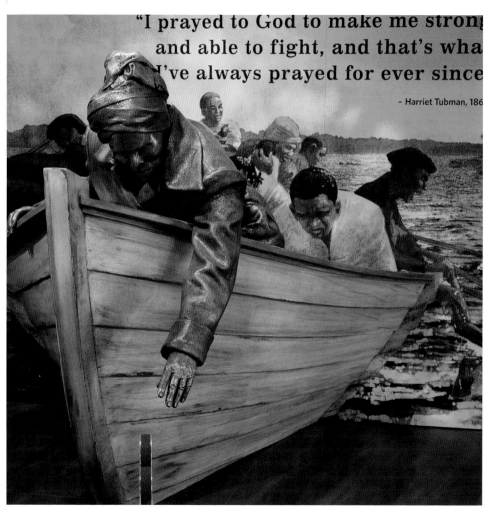

"I prayed to God to make me strong and able to fight, and that's what I've always prayed for ever since

- Harriet Tubman, 186

Harriet Tubman National Historical Park

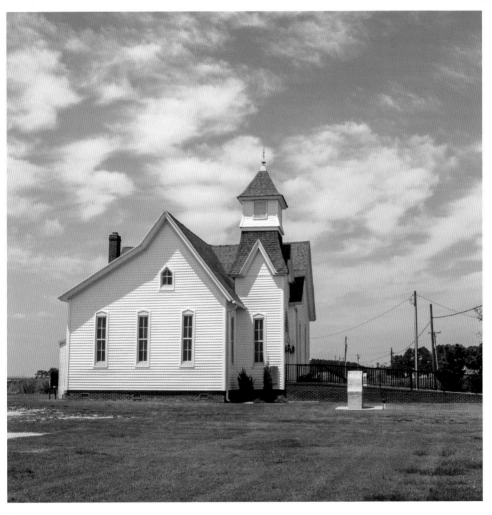

Hoopers Island

Cambridge

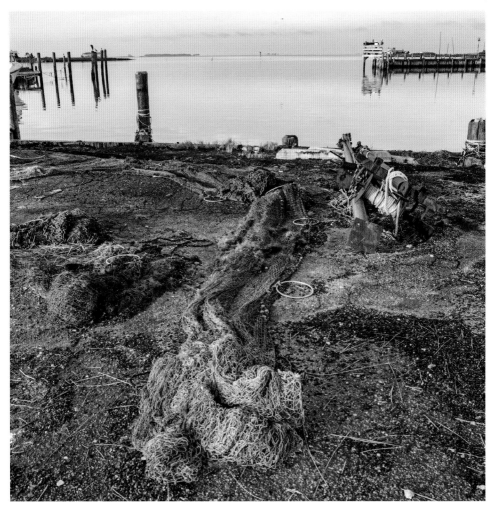

Wingate, Honga River

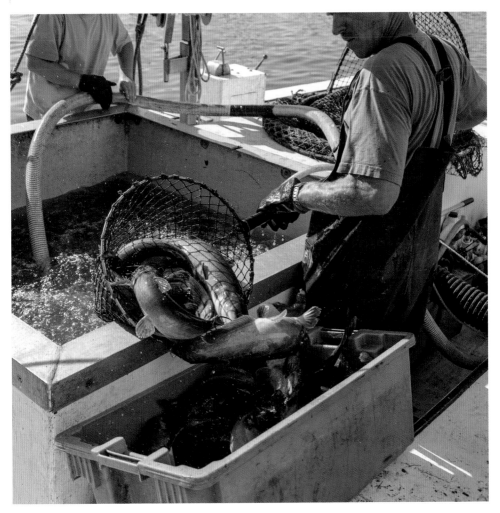

Choptank, Choptank River

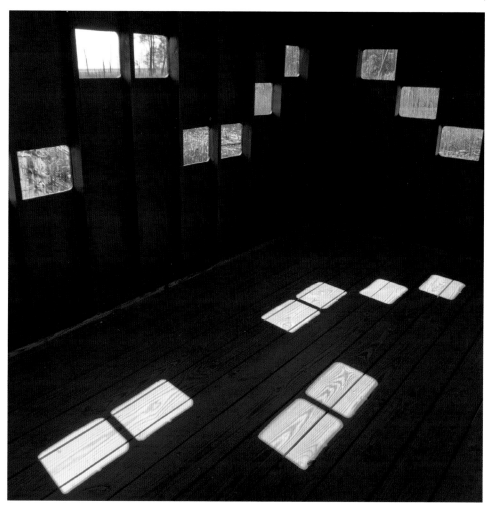

Blackwater National Wildlife Refuge

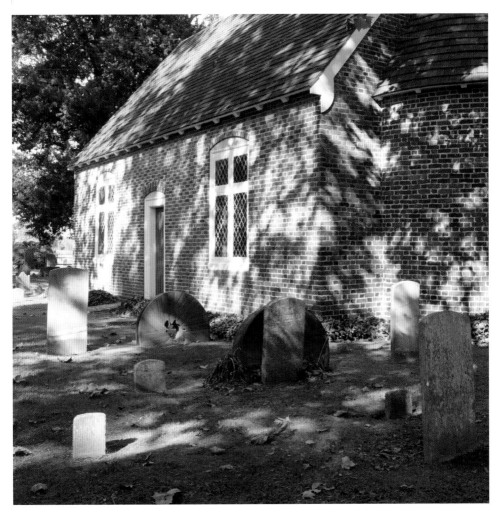

Old Trinity Church, Church Creek

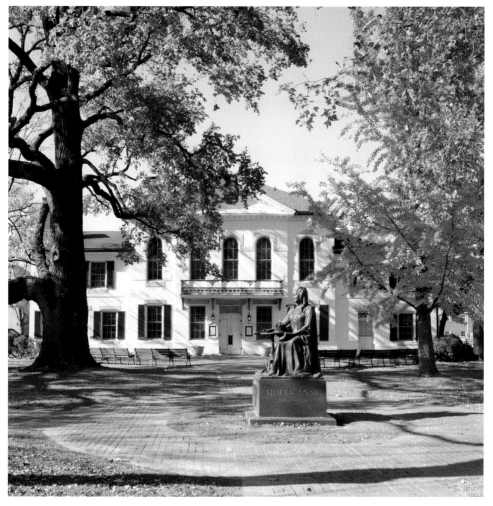

Queen Anne's County Courthouse, Centreville

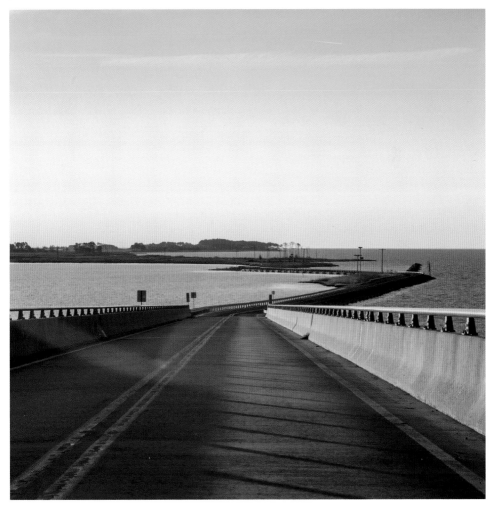

Hoopers Island

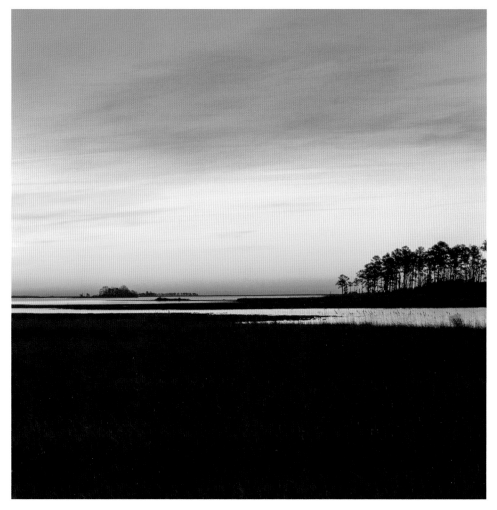

Blackwater National Wildlife Refuge

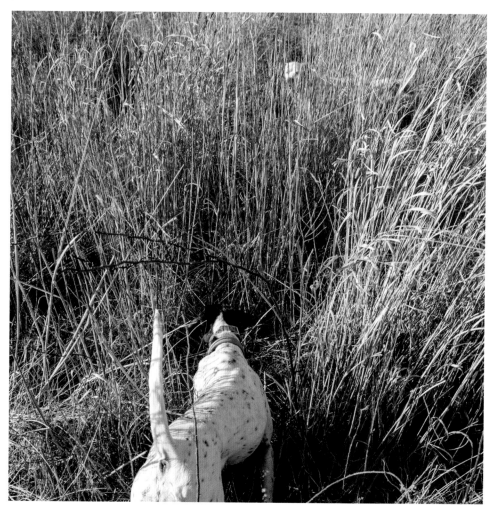

Quail hunting

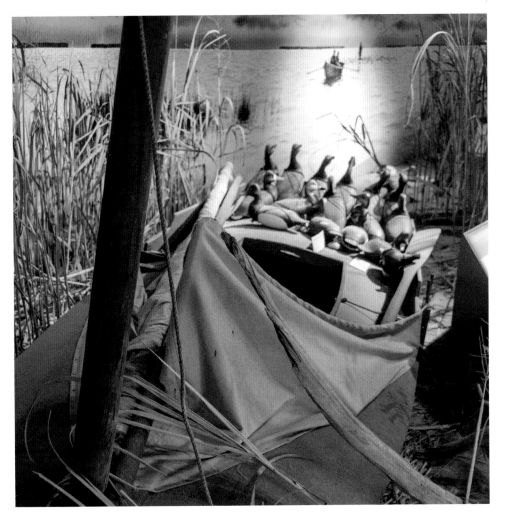

Ward Museum of Wildfowl Art, Salisbury

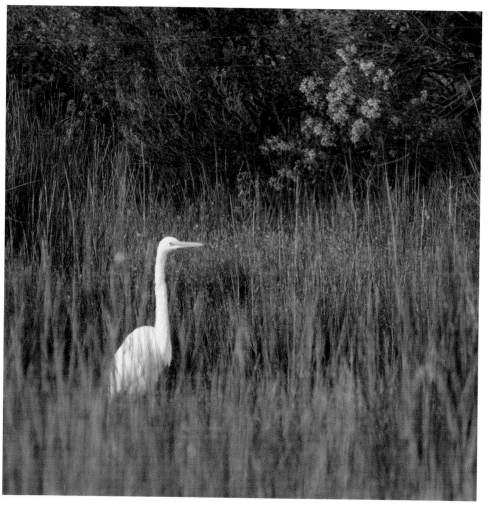

Egret

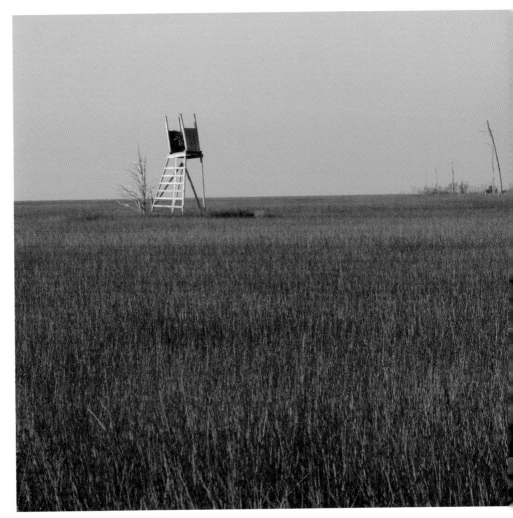

Along Bishop's Head Road

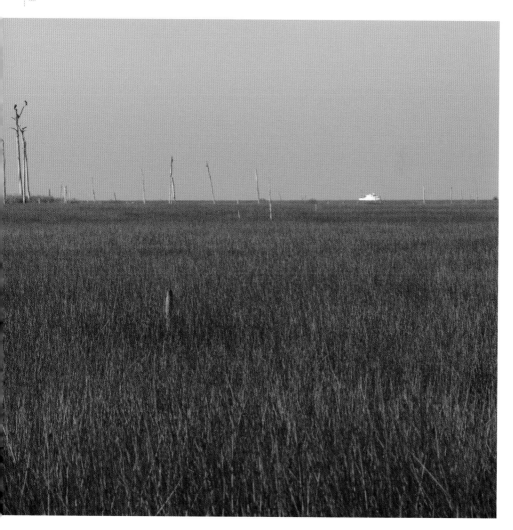

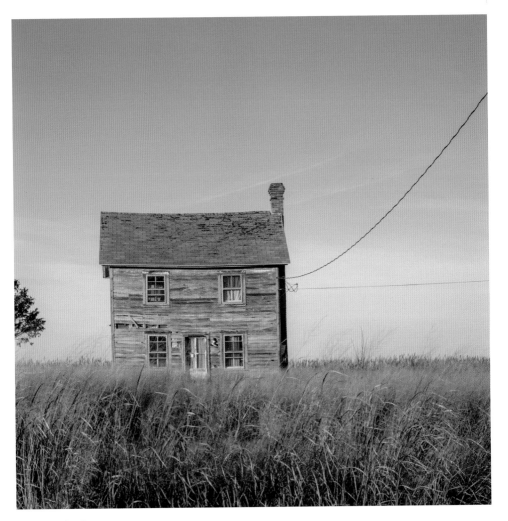

Hoopers Island

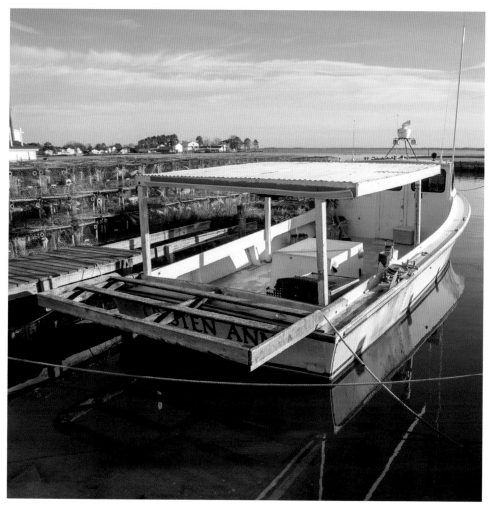

Fishing Creek

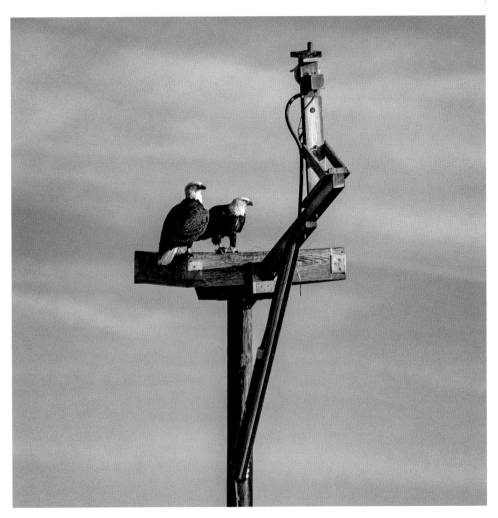

Bald eagles, Blackwater National Wildlife Refuge

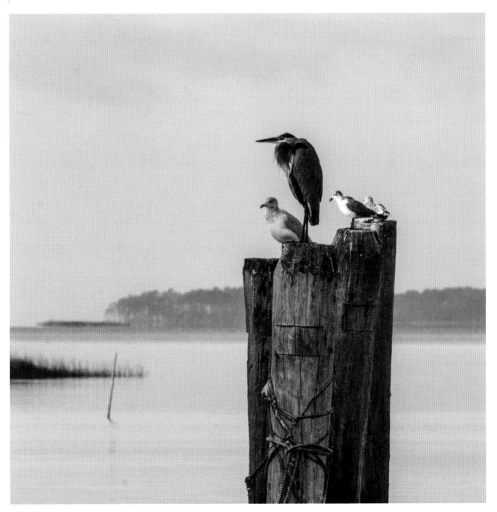

Wingate, Honga River

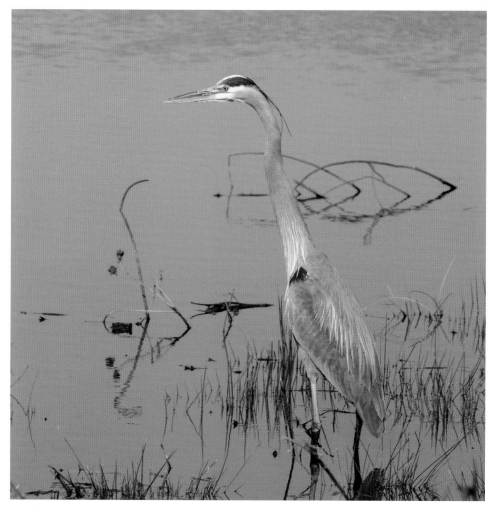

Great blue heron, Blackwater National Wildlife Refuge

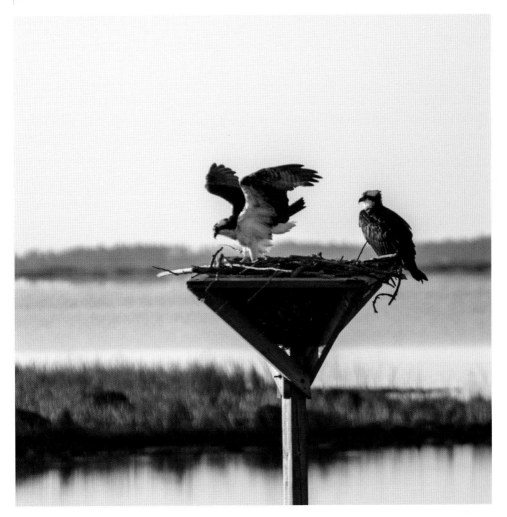

Ospreys, Blackwater National Wildlife Refuge

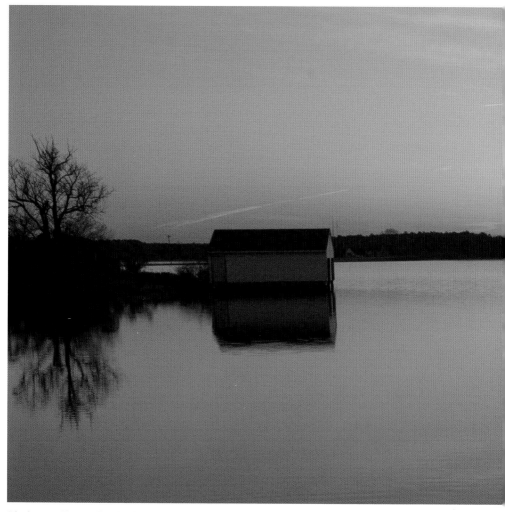

Blackwater National Wildlife Refuge

Wye Mills

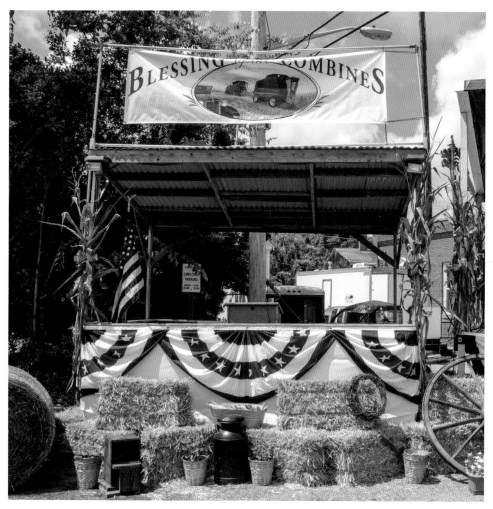

Snow Hill

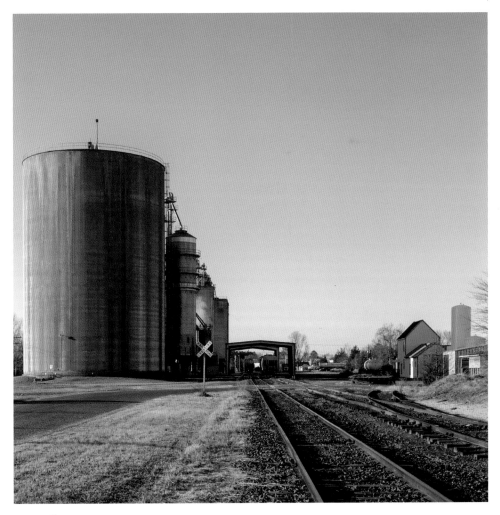

Snow Hill

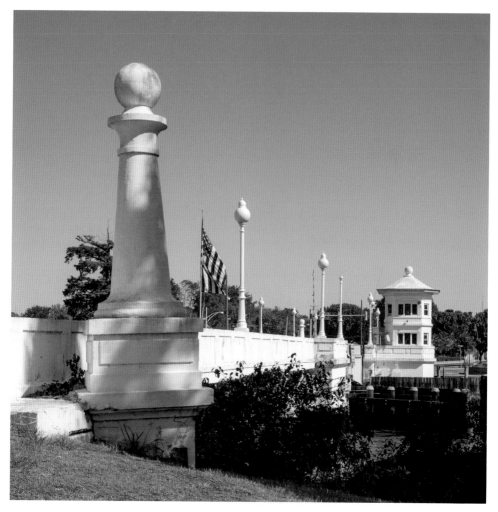

Pocomoke City, Pocomoke River

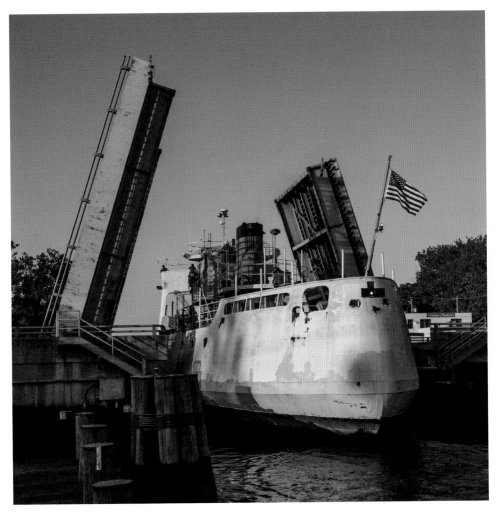

Salisbury, Wicomico River

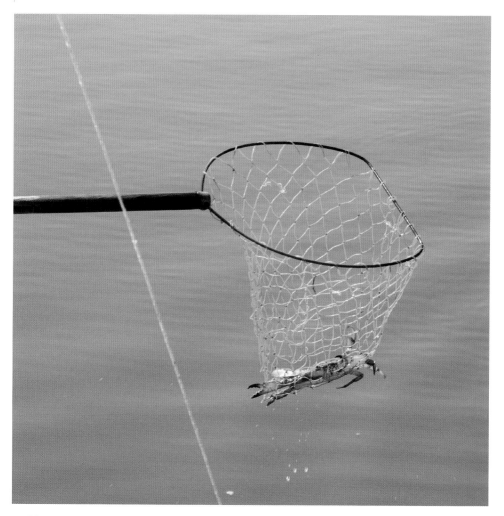

Crabbing

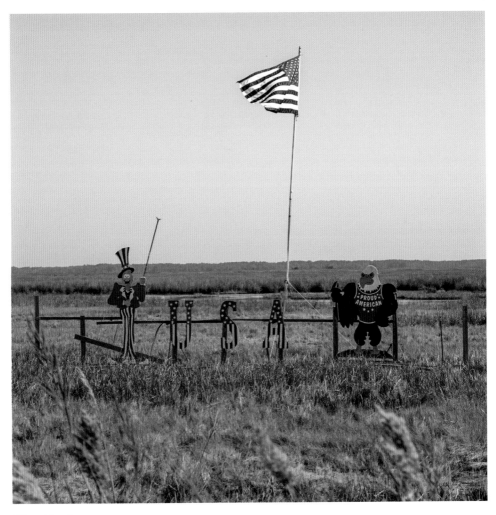

Elliott Island

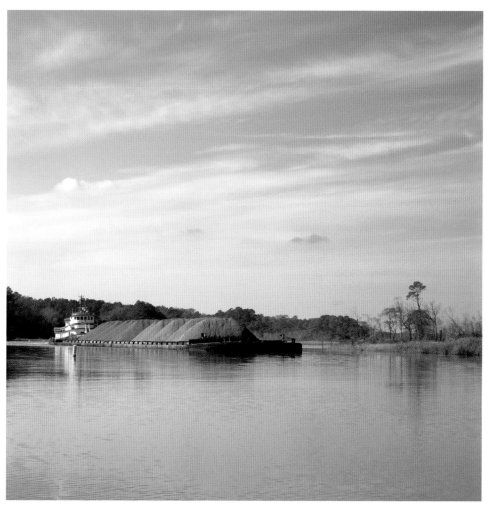

Rockawalkin, Wicomico River

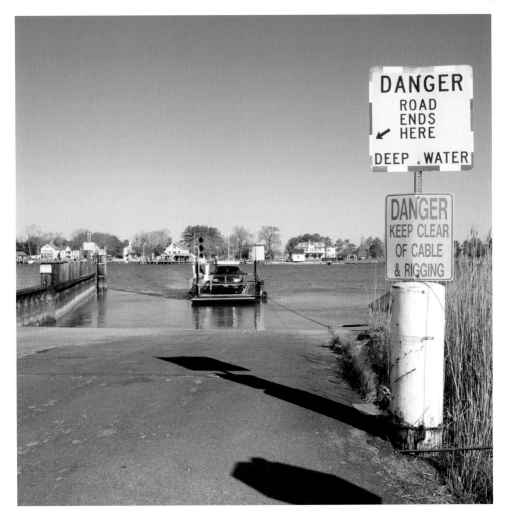

Whitehaven, Wicomico River

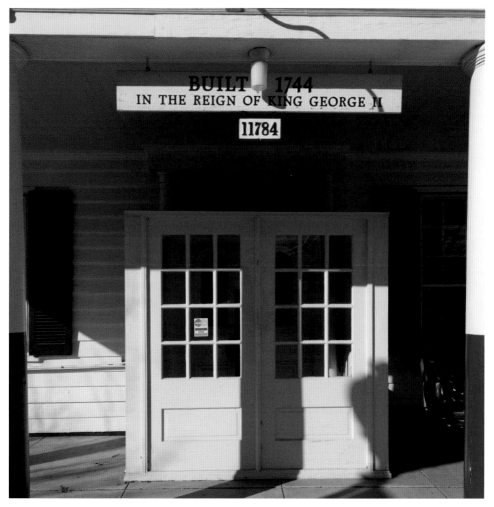

BUILT 1744
IN THE REIGN OF KING GEORGE II

11784

Princess Anne

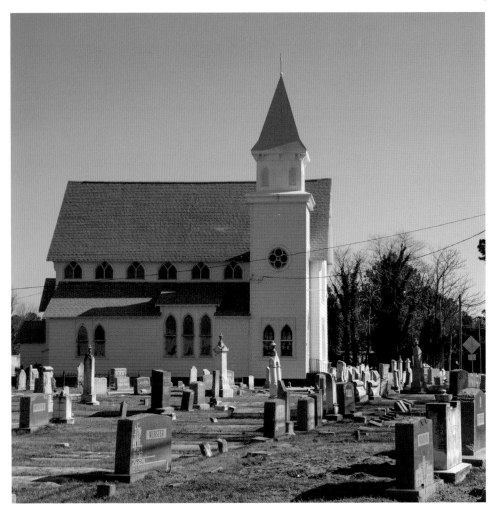

St. John's United Methodist Church, Deal Island

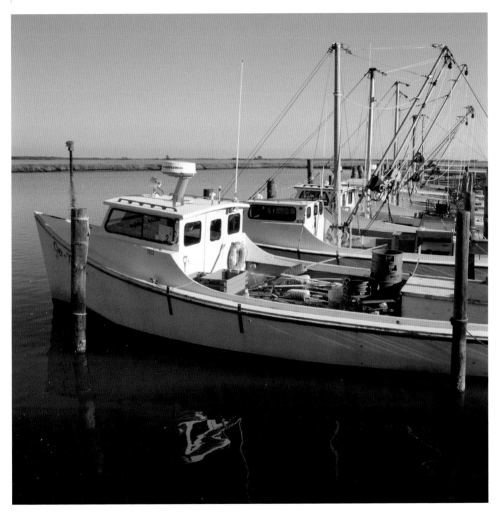

Rumbly

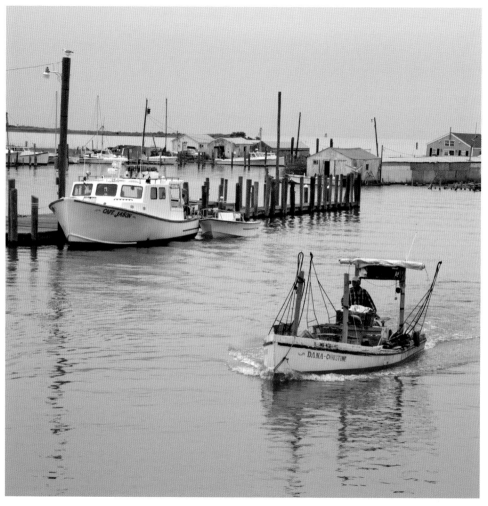

Smith Island

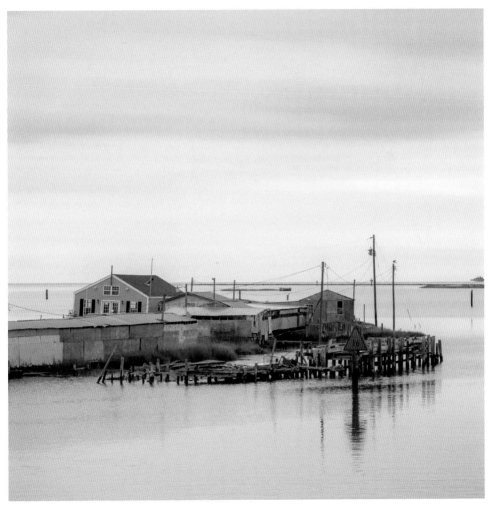

Smith Island

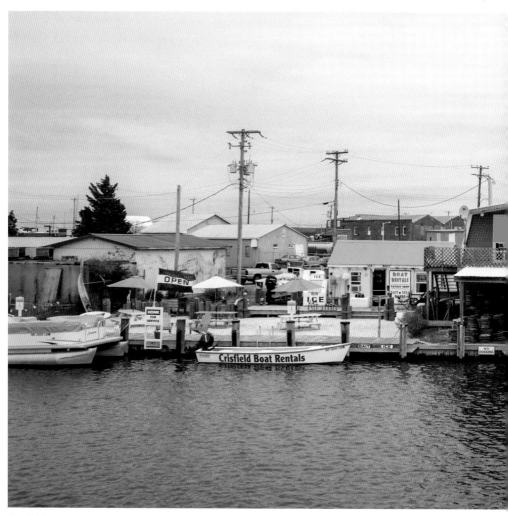

Crisfield

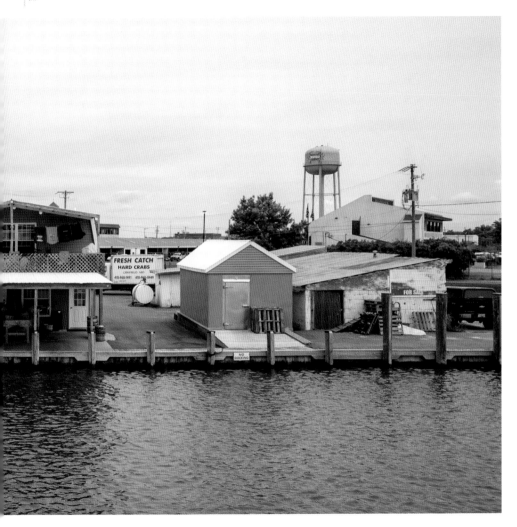

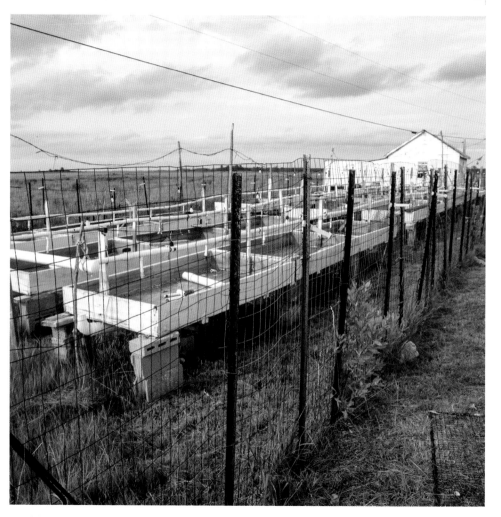

Rumbly

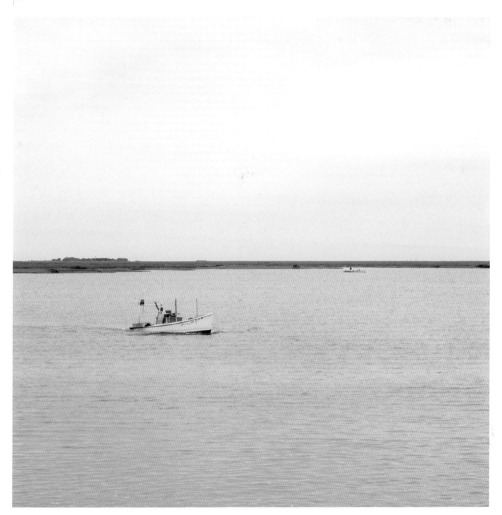

Chesapeake Bay

Antelo Devereux Jr. has been making photographs since he was given a Kodak Duaflex II box camera at age 10. Thus began a hobby that has grown increasingly serious as time has gone by. He is a graduate of Harvard University and has taken several courses at the Maine Media Center; exhibited in Maine, Vermont, Pennsylvania, and Delaware; and published 10 photography books. He spends his time in Pennsylvania and Maine with his family.

Other Schiffer Books by the Author:
Coastal Maine, ISBN 978-0-7643-5575-2
Brandywine Valley, ISBN 978-0-7643-5574-5
The Jersey Shore, ISBN 978-0-7643-5576-9

Other Schiffer Books on Related Subjects:
Chesapeake Wildlife: Stories of Survival and Loss, Pat Vojtech, ISBN 978-0-8703-3536-5
Bodine's Chesapeake Bay Country, A. Aubrey Bodine and Jennifer Bodine, ISBN 978-0-8703-3562-4

Copyright © 2022 by Antelo Devereux Jr.

Library of Congress Control Number: 2021942840

Designed by Chris Bower
Type set in Bell MT/Cambria

ISBN: 978-0-7643-6364-1
Printed in India

Published by Schiffer Publishing, Ltd.
4880 Lower Valley Road
Atglen, PA 19310
Phone: (610) 593-1777; Fax: (610) 593-2002
Email: Info@schifferbooks.com
Web: www.schifferbooks.com

For our complete selection of fine books on this and related subjects, please visit our website at www.schifferbooks.com. You may also write for a free catalog.

Schiffer Publishing's titles are available at special discounts for bulk purchases for sales promotions or premiums. Special editions, including personalized covers, corporate imprints, and excerpts, can be created in large quantities for special needs. For more information, contact the publisher.

We are always looking for people to write books on new and related subjects. If you have an idea for a book, please contact us at proposals@schifferbooks.com.